BETTER TOGETHER

Life Is Best with a Friend Like You

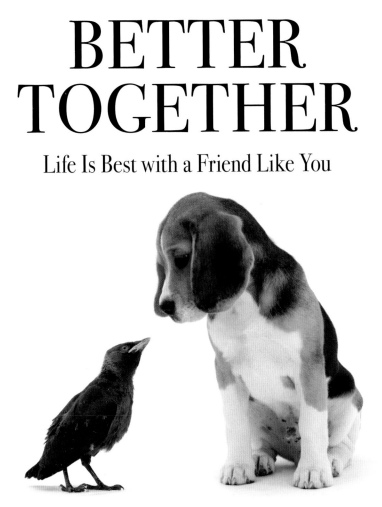

Warren Photographic

ZONDERVAN

Better Together

Copyright © 2019 by Warren Photographic

This title is also available as a Zondervan ebook.

Requests for information should be addressed to:

Zondervan, *3900 Sparks Dr. SE, Grand Rapids, Michigan 49546*

Library of Congress Cataloging-in-Publication Data

ISBN 978–0–310-35412-3 (HC)
ISBN 978–0–310-45169-3 (eBook)

Art direction: Patti Evans

Interior design: Susanna Chapman

Printed in China

19 20 21 22 23 DSC 11 10 9 8 7 6 5 4 3

Contents

Introduction

Close friends are people we can be our true selves with. More than just social media connections, they're companions we can lean on when times are hard and laugh with when everything's going well. Sometimes friends look like us and act like us, and we see life through the same spectacles. Yes, there's a certain measure of comfort that goes with that. It's safe. We're assured that we don't think and act alone. *There's someone else in the world who gets me because they're a lot like me.*

This is not to say our differences don't play a part in the mysterious transaction that makes a friendship; quite the contrary. Sometimes it's our differences that intermingle to create something so uniquely original that the product that remains is truly one-of-a-kind, unable to be replicated. I learn to love you for the person you are that I am not, and you reply in kind.

And this is the wonderful paradox of friendship. Our similarities might bring us to together, but our differences are the secret ingredient that forms the life-long bond.

Life would be boring if we were all exactly the same. We're really not so different, but our differences are what truly makes us Better Together.

Friendship

A man, Sir, should keep his friendships in constant *repair*.

—*Samuel Johnson*

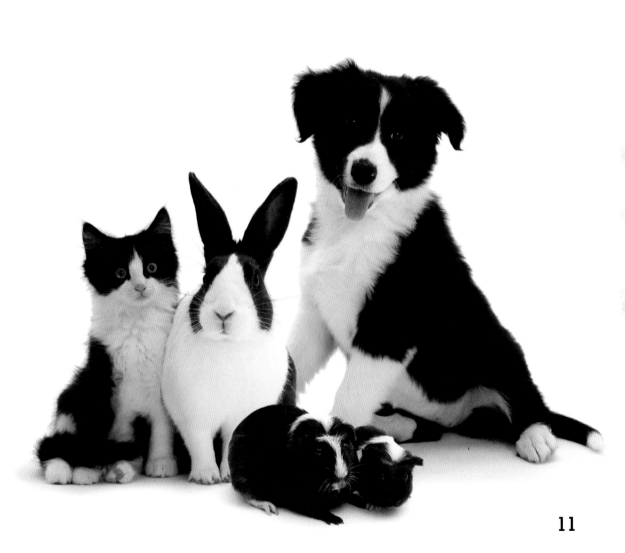

Friendship is a single soul dwelling in two bodies.

—*Aristotle*

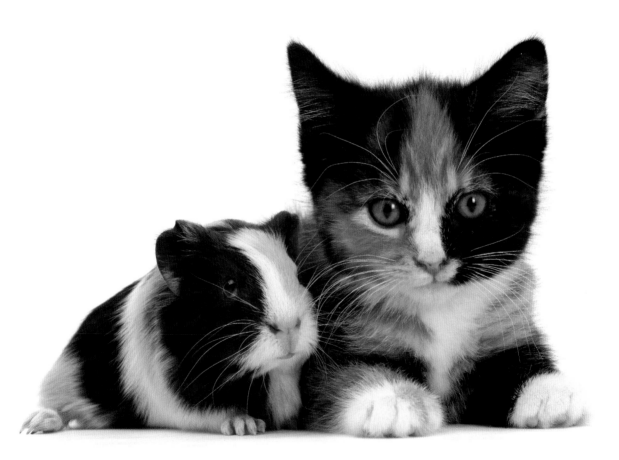

What draws people to be friends is that they see the same *truth*. They share it.

—C. S. Lewis

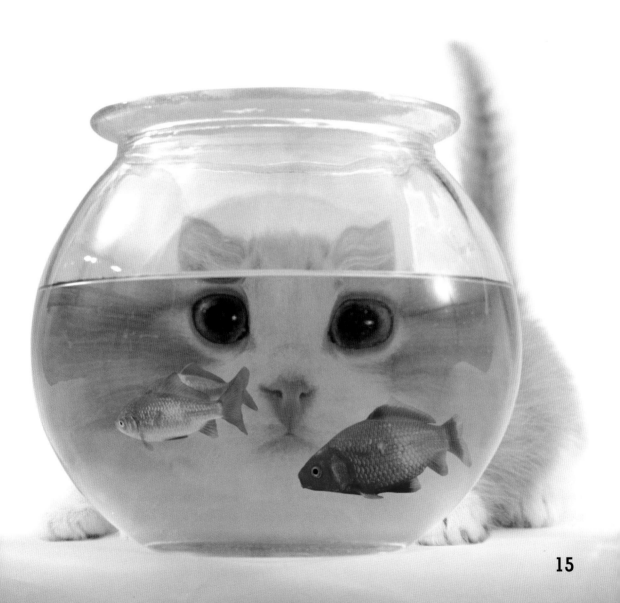

Do I not destroy my enemies when I make them my *friends*?

—Abraham Lincoln

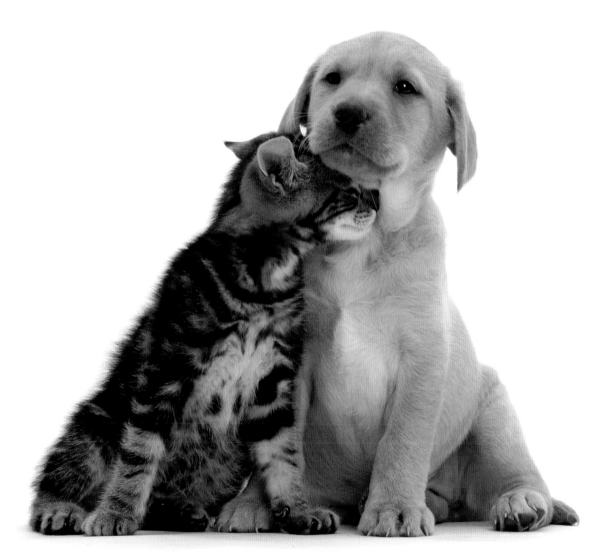

A friend *loves* at all times, and a brother is born for adversity.

—The Book of Proverbs

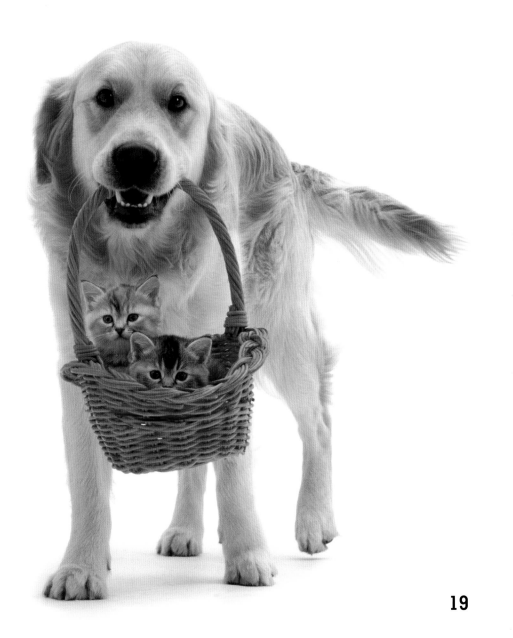

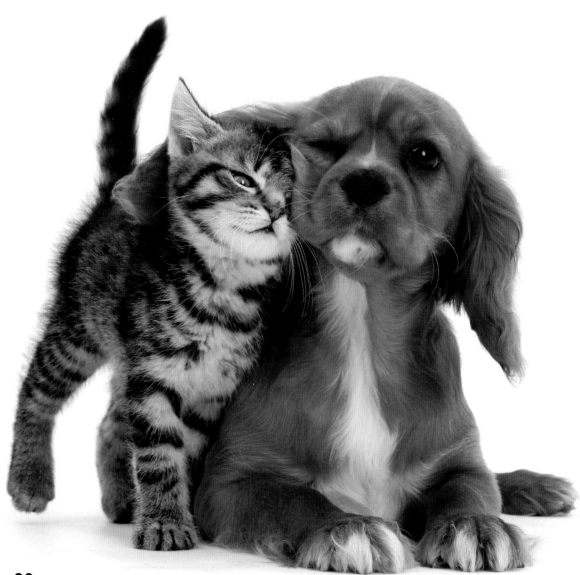

My best friend is the one who brings out the *best* in me.

—Henry Ford

I would rather walk with a friend in the dark than walk alone in the *light.*

—Helen Keller

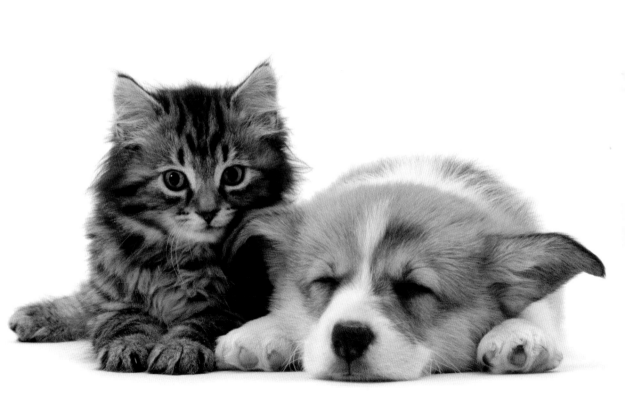

As iron *sharpens* iron, so a friend sharpens a friend.

—The Book of Proverbs

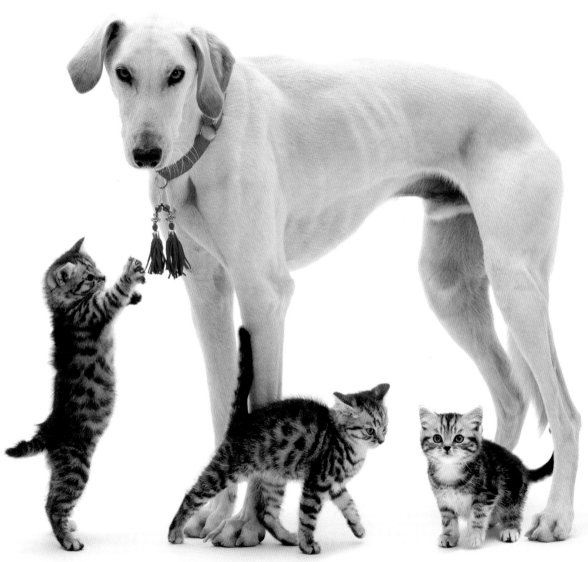

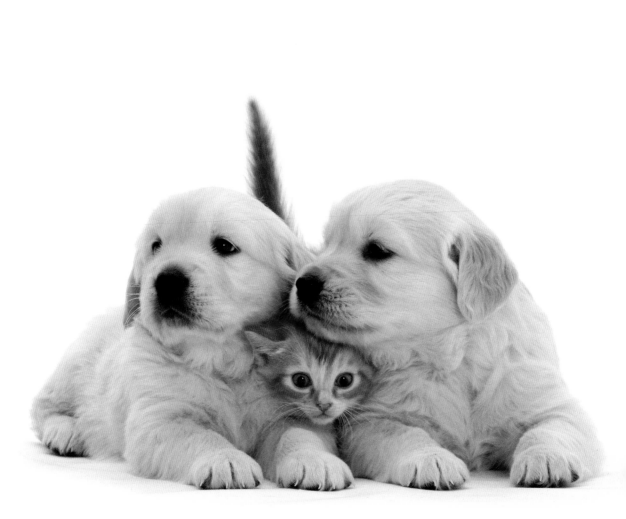

There is nothing on this earth to be prized more than true *friendship*.

—Thomas Aquinas

Unity & Togetherness

"*Stay*" is a charming word in a friend's vocabulary.

—Louisa May Alcott

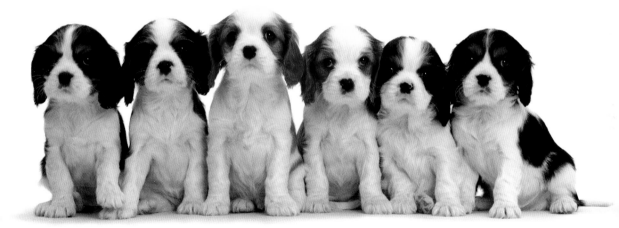

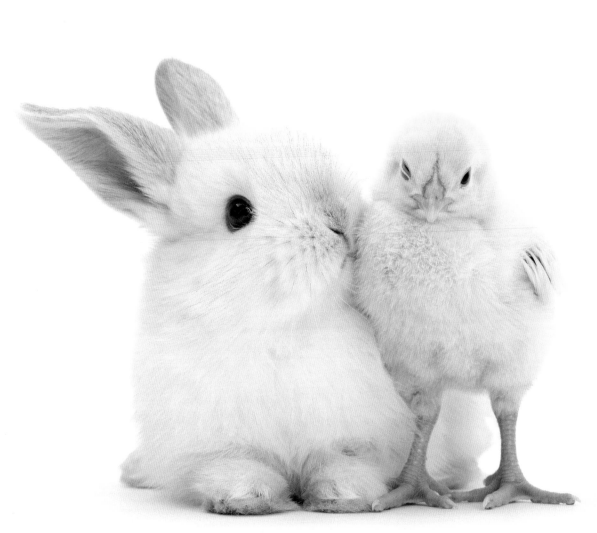

Parents are friends that life gives us; friends are parents that the *heart* chooses.

—Comtesse Diane

To be one, to be united is a great thing. But to respect the right to be *different* is maybe even greater.

—Bono

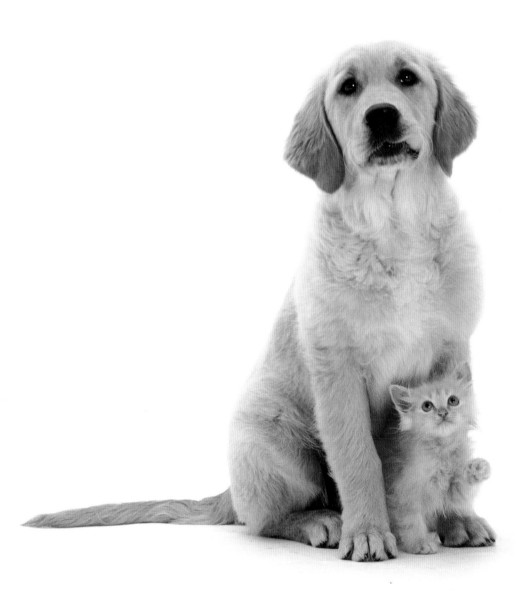

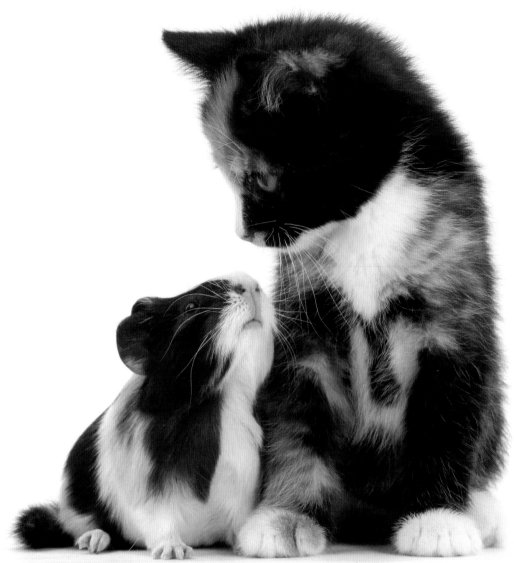

Unity does not mean sameness. It means *oneness* of purpose.

—Priscilla Shirer

Great things are done by a series of *small things* brought together.

—Vincent van Gogh

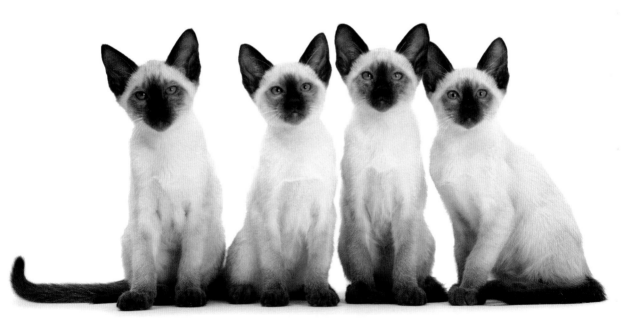

We cannot live only for ourselves. A thousand fibers connect us with our fellow men; and among those fibers, as *sympathetic threads*, our actions run as causes, and they come back to us as effects.

—Henry Melville

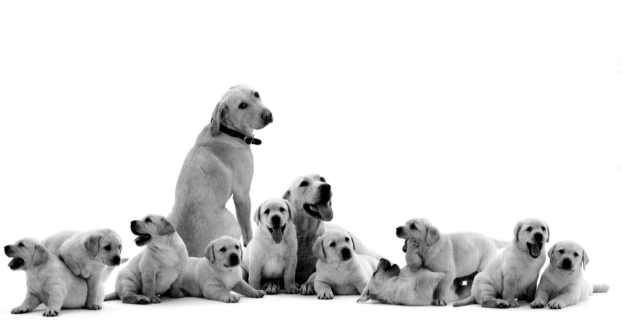

Oneness doesn't mean sameness. Oneness means working together toward the same goal. People working together toward the *same goal* will have to, out of necessity, communicate, cooperate, and merge strengths with strengths while overlooking or overcoming each other's weaknesses.

—Tony Evans

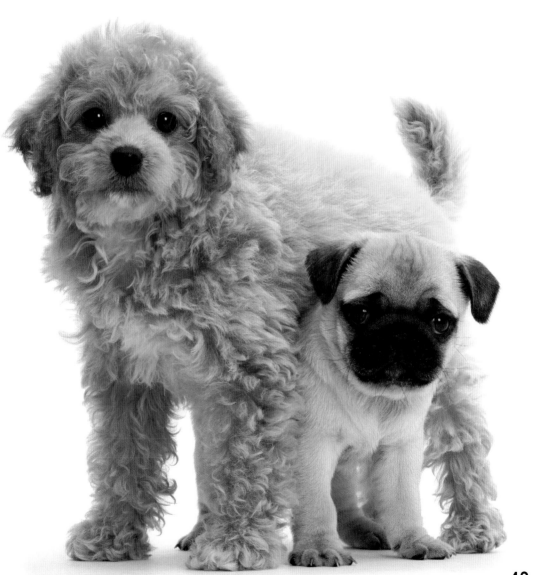

Love & Compassion

Wear a *smile* and have friends; wear a scowl and have wrinkles.

—George Eliot

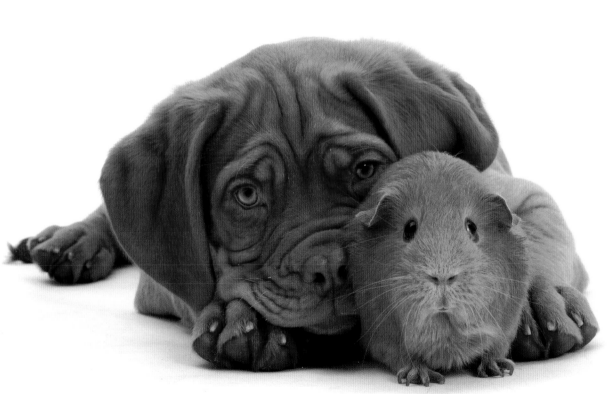

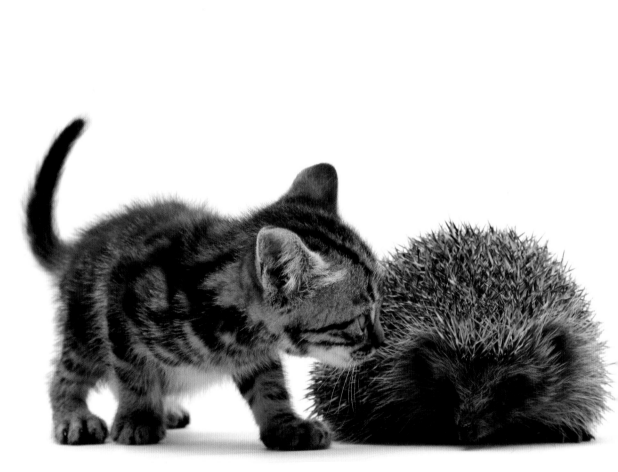

If you judge people, you have no time to *love* them.

—Mother Teresa

To love someone is to acknowledge the goodness of who they are. Through loving a person we *awaken* their awareness of their own innate goodness. It is as though they cannot know how worthy they are until they look into the mirror of our love and see themselves.

—John Gray

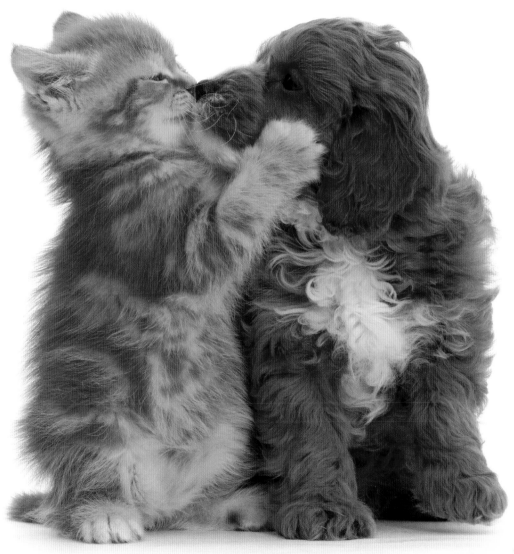

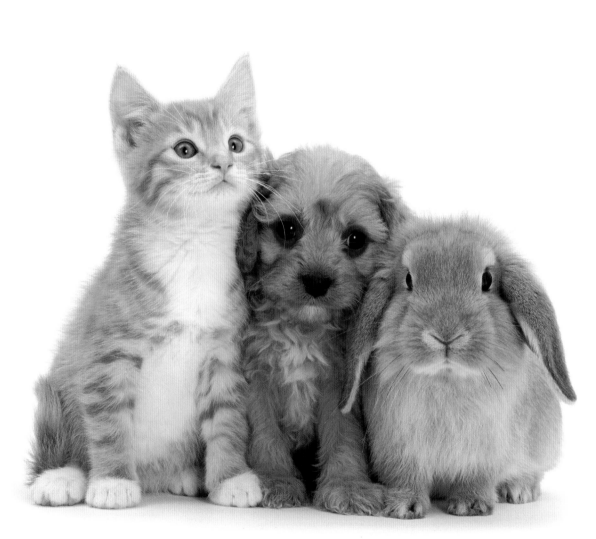

Kindness is a universal language regardless of age, nationality or religion.

—Alex Ferguson

What I'm not confused about is the world needing much *more love*, no hate, no prejudice, no bigotry and more unity, peace and understanding. Period.

—Stevie Wonder

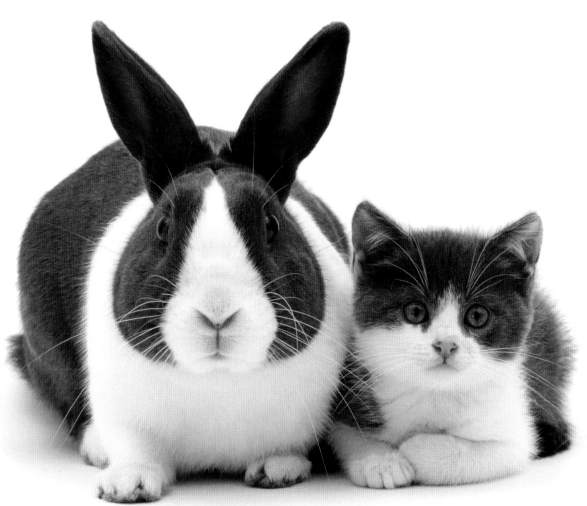

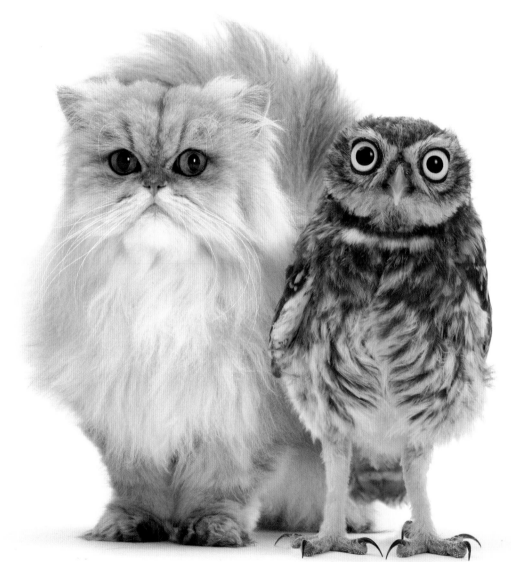

With *compassion*, we see benevolently our own human condition and the condition of our fellow beings. We drop prejudice. We withhold judgment.

—Christina Baldwin

Compassion is the chief law of human existence.

—Fyodor Dostoevsky

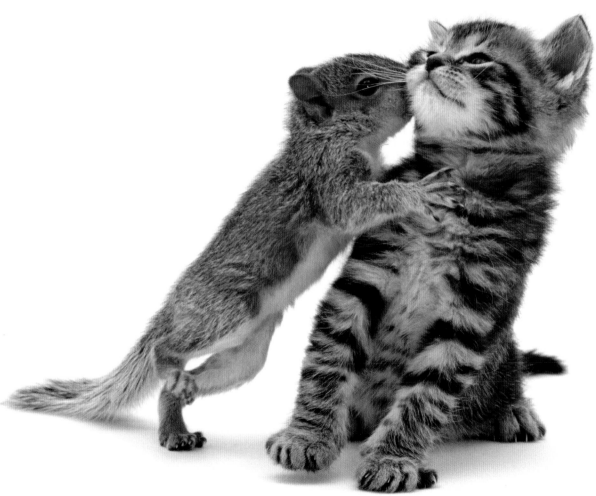

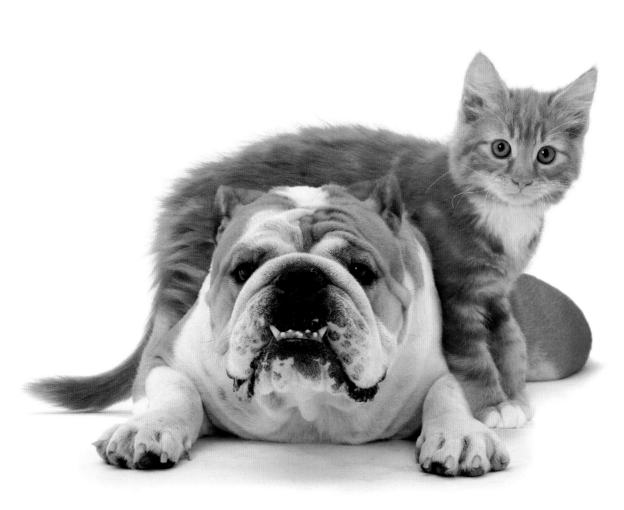

Love is not love that alters when it alteration finds.

—William Shakespeare

Our task must be to free
ourselves by widening
our circle of *compassion*
to embrace all living
creatures and the whole of
nature and its beauty.

—*Albert Einstein*

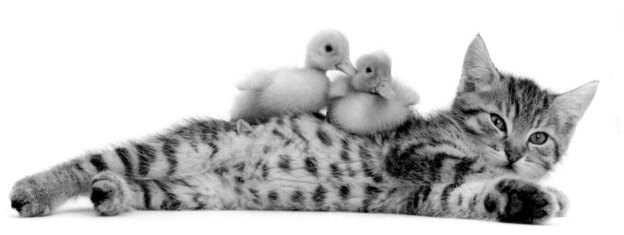

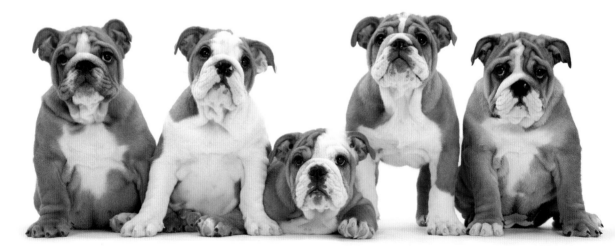

Human *kindness* has never weakened the stamina or softened the fiber of a free people. A nation does not have to be cruel to be tough.

—Franklin D. Roosevelt

Compassion requires us to be weak with the weak, vulnerable with the vulnerable, and powerless with the powerless. Compassion means full *immersion* in the condition of being human.

—Henri Nouwen

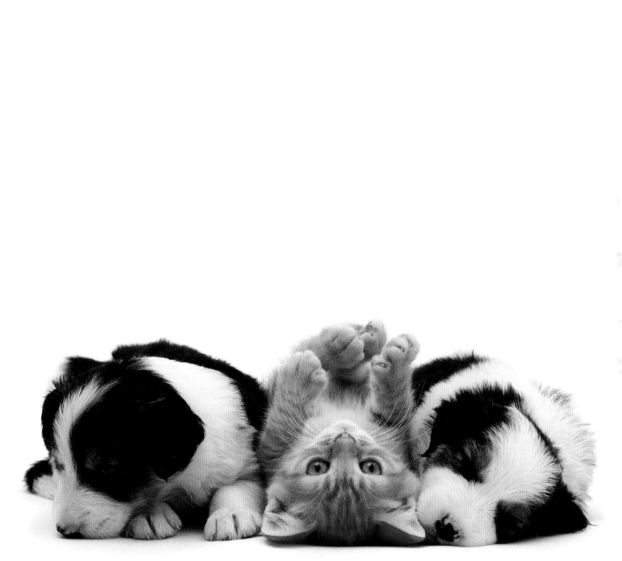

Four

Respect

How necessary it is to cultivate a *spirit of joy*. It is a psychological truth that the physical acts of reverence and devotion make one feel devout. The courteous gesture increases one's respect for others. To act lovingly is to begin to feel loving, and certainly to act joyfully brings joy to others which in turn makes one feel joyful. I believe we are called to the duty of delight.

—Dorothy Day

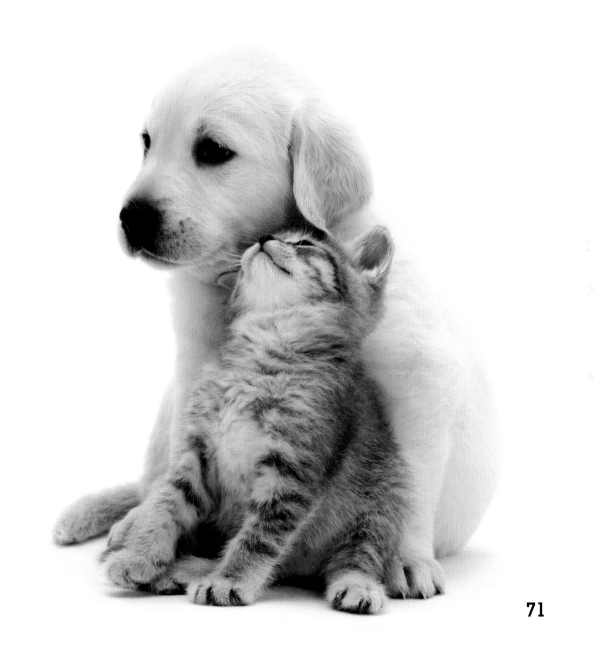

For to be free is not merely
to cast off one's claims,
but to live in a way that
respects and enhances
the freedom of others.

—Nelson Mandela

The best thing to give to your enemy is *forgiveness*; to an opponent, tolerance; to a friend, your heart; to your child, a good example; to a father, deference; to your mother, conduct that will make her proud of you; to yourself, respect; to all others, charity.

—Benjamin Franklin

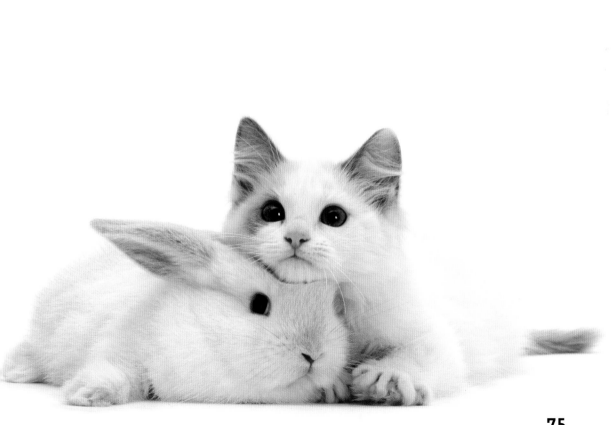

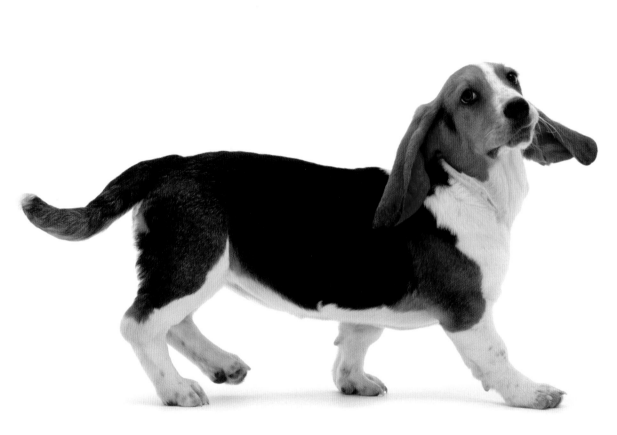

Friendship is a *union of spirits*, a marriage of hearts, and the bond there of virtue.

—Samuel Johnson

Five

Peace & Harmony

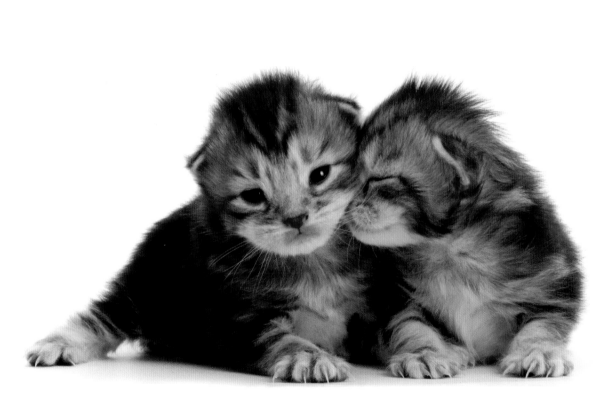

If we have no peace, it is because we have forgotten that we *belong* to each other.

—Mother Teresa

Everyone has a right to peaceful coexistence, the basic personal freedoms, the alleviation of suffering, and the *opportunity* to lead a productive life.

—Jimmy Carter

We make our friends; we make our enemies; but God makes our next-door *neighbor*.

—G. K. Chesterton

Friendship's a noble name, 'tis *love* refined.

—Susannah Centlivre

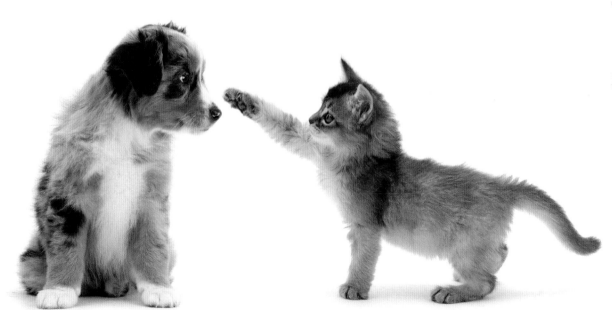

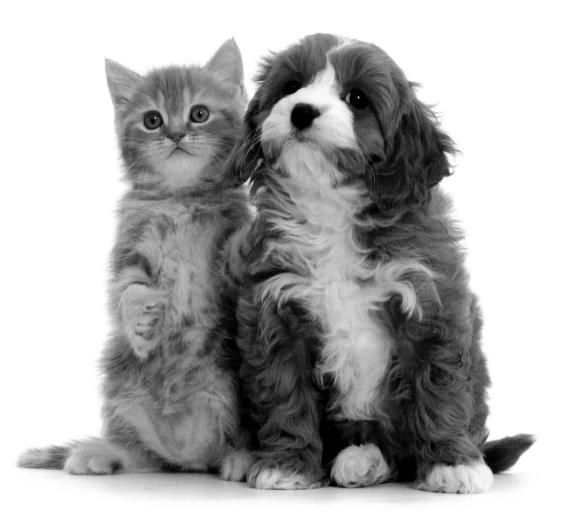

The bird, a nest;
the spider, a web;
man, *friendship*.

—William Blake

Friendship is the only cement that will ever hold the world *together*.

—Woodrow Wilson

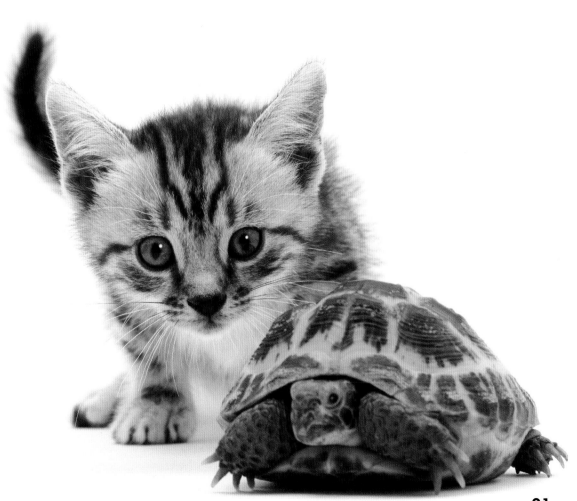

Diversity

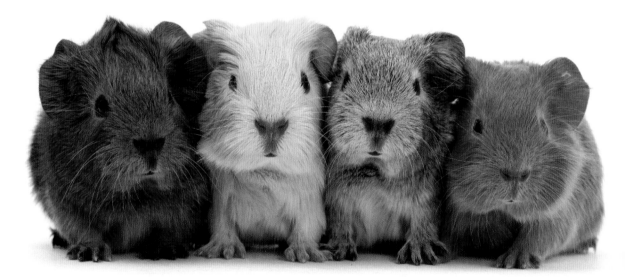

We may have different religions, different languages, different colored skin, but we all belong to *one human race*.

—Kofi Annan

Human beings are endowed with infinitely *varying* qualities and dispositions, and each one is different from the others. We cannot make them all the same. It would be a pretty dull world if we did.

—Winston Churchill

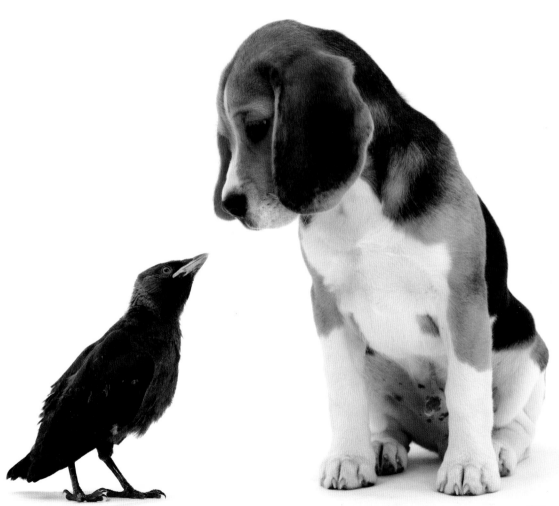

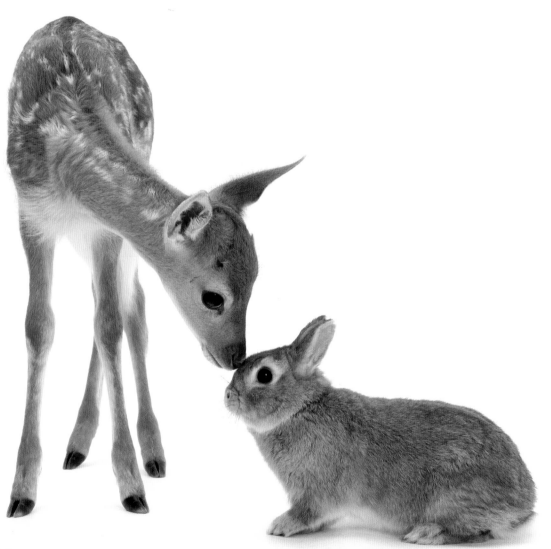

The number one problem in our world is alienation, rich versus poor, black versus white, labor versus management, conservative versus liberal, East versus West. . . . But Christ came to bring about reconciliation and *peace*.

—Billy Graham

May the God of peace arouse in all an authentic desire for *dialogue* and reconciliation. Violence cannot be overcome with violence. Violence is overcome with peace.

—Pope Francis

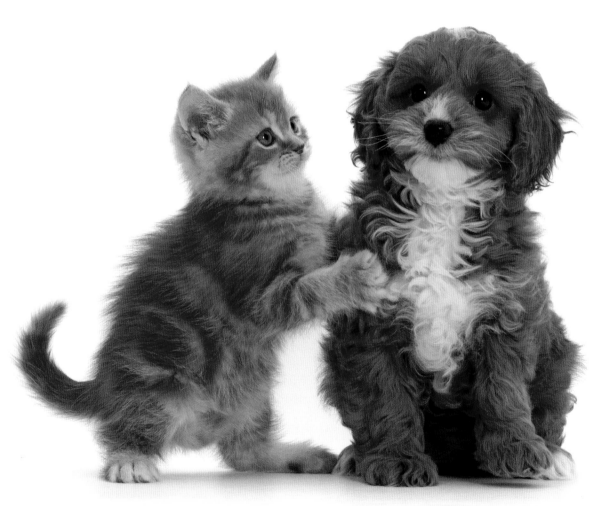

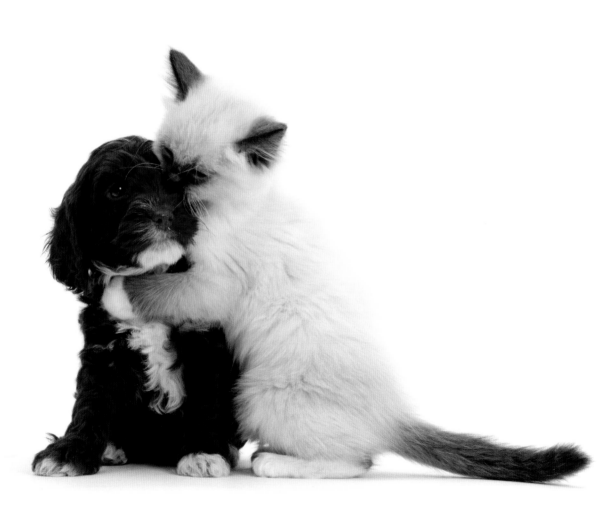

Love is the only force capable of transforming an enemy into a friend.

—Martin Luther King, Jr.

Observe good faith and justice toward all nations. Cultivate peace and *harmony* with all.

—George Washington

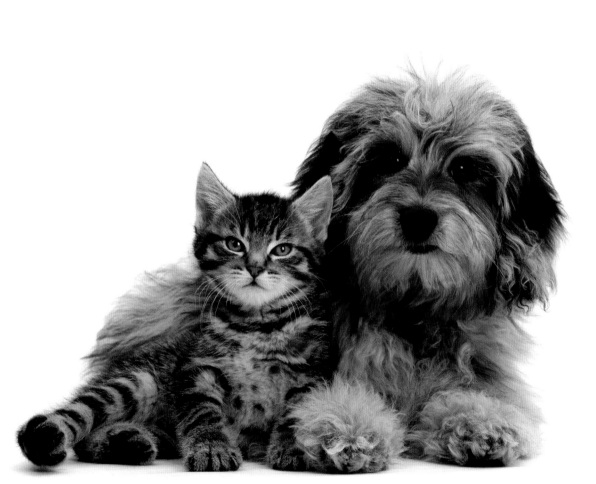

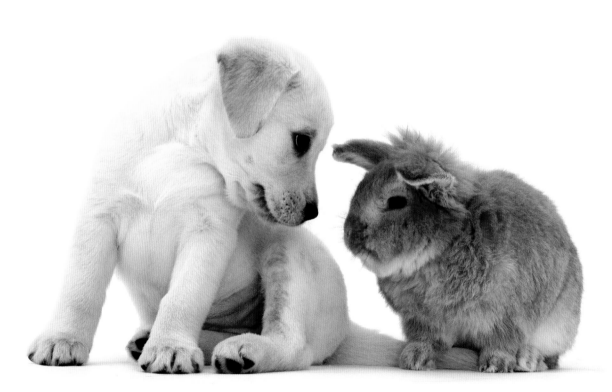

Difference is of the essence of humanity.

—John Hume

Triumph & Strength

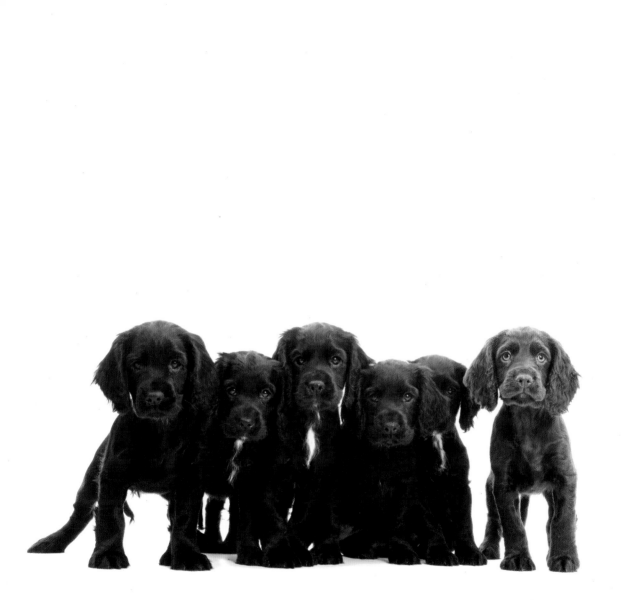

Prosperity provideth, but *adversity* proveth friends.

—Queen Elizabeth I

Progress is impossible without *change*.

—George Bernard Shaw

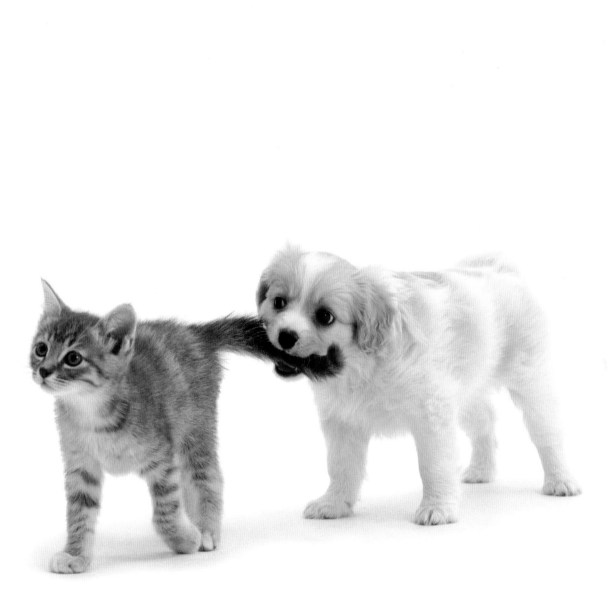

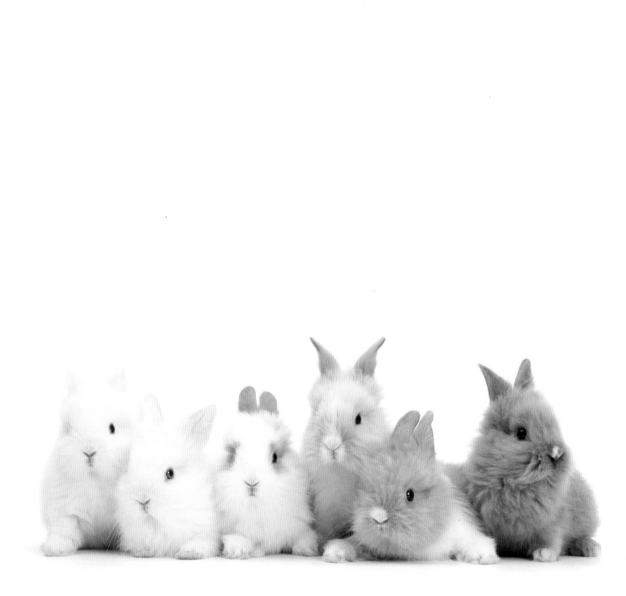

Alone we can do so little; *together* we can do so much.

—Helen Keller

Change will not come if we wait for some other person or some other time. We are the ones we've been waiting for. We are the change that we seek.

—Barack Obama

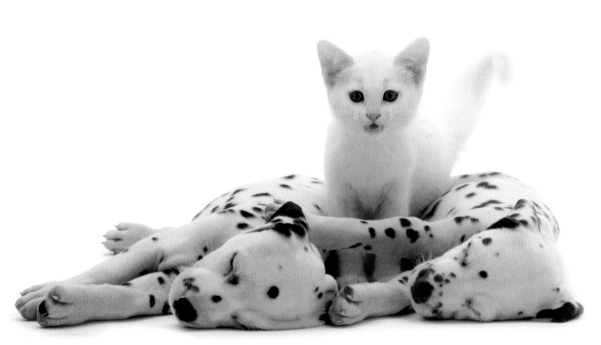

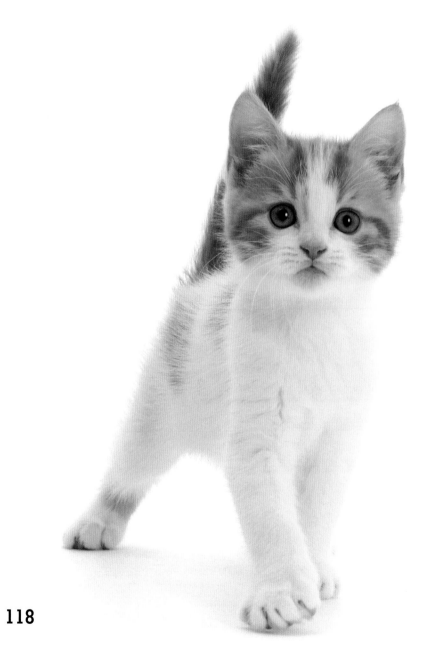

I know in my heart that man is good. That what is right will always eventually triumph. And there's *purpose* and worth to each and every life.

—Ronald Reagan

Unity is strength . . . when there is teamwork and collaboration, wonderful things can be achieved.

—Mattie Stepanek

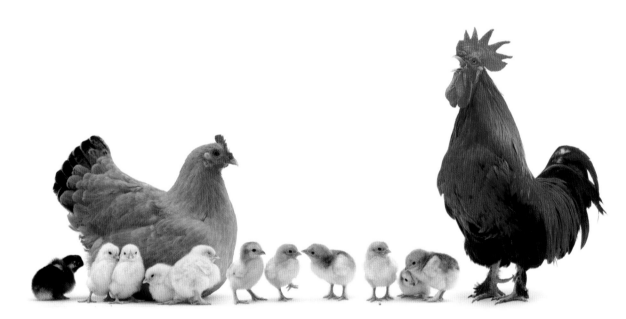

Notes

Notes are listed by page numbers.

Friendship

12: Aristotle (384 BC–322 BC).

14: C.S. Lewis, *The Four Loves* (New York: Harcourt Brace, 1960). Copyright © C.S. Lewis Pte. Ltd. 1960. Extract reprinted by permission.

16: Abraham Lincoln during Civil War interview. http://www.historynet.com/abraham -lincoln-quotes.

21: Attributed to Henry Ford (1948). https:// en.wikiquote.org/wiki/Henry_Ford.

22: Quoted in Joseph P. Lash, *Helen and Teacher: The Story of Helen Keller and Anne Sullivan* (New York: Delacorte Press, 1980), 496. https:// quoteinvestigator.com/2013/05/10 /walk-with-friend/#note-6236–1.

27. Thomas Aquinas (1225–1274).

Unity & Togetherness

34. Bono, quoted in Carol O' Connor, *Secrets of Great Leaders* (New York: Hatchette, 2015), 112.

37. Priscilla Shirer, *Gideon* (Nashville: Lifeway Press, 2013). Use with permission.

38. Vincent Van Gogh in his letter to Theo, from The Hague (22 October 1882).

42: Excerpted from *Kingdom Marriage*, by Tony Evans, a Focus on the Family book published by Tyndale House Publishers, Inc. © 2016 Tony Evans. Used with permission.

Love & Compassion

49: The Writings of Mother Teresa of Calcutta © by the Mother Teresa Center, exclusive licensee throughout the world of the Missionaries of Charity for the works of Mother Teresa. Used with permission.

50: John Gray, "The Law of Attraction Library," Lawofattractionlibrary.org. http://www .thelawofattraction.org/john-gray/.

54: Nadeska Alexis, "Stevie Wonder Clears Up Frank Ocean Sexuality Comments," TimeInc., 09/02/2012. Used with permission.

57: Excerpt from *Life's Companion: Journal Writing as a Spiritual Practice*, by Christina Baldwin, copyright © 1990 by Christina Baldwin. Used by permission of Bantam Books, an imprint of

Random House, a division of Penguin Random House LLC. All rights reserved.

58: Fyodor Dostoevsky, *The Idiot* (1881), 142. https://www.gutenberg.org/files/2638/2638-h/2638-h.htm.

61: William Shakespeare, Sonnet 116 (1616).

62: Albert Einstein, Albert Einstein Archives, © The Hebrew University of Jerusalem. Used with permission.

65: Franklin D. Roosevelt, Speech in 1935, as quoted by Donna E. Shalala, as Secretary of

Health and Human Services, in a speech to the American Public Welfare Association (27 February 1995).

66: Excerpt from *Compassion: A Reflection on the Christian Life*, by Donald P. McNeill, Douglas A. Morrison, and Henri J.M. Nouwen, © 1982 by Donald P. McNeill, Douglas A. Morrison, and Henri J.M. Nouwen. Used by permission of Doubleday, an imprint of the Knopf Doubleday Publishing Group, a division of Penguin Random House LLC. All rights reserved.

Respect

70: Dorothy Day, "On Pilgrimage," The Catholic Worker Movement, January 1956. Used with permission. www.catholicworker.org/dorothyday/articles/697.html.

73: Nelson Mandela, *Long Walk to Freedom* (New York: Holt, Rinehart Winston, 2000), 624.

74: Benjamin Franklin. http://www.foundingfatherquotes.com/father/quotes/3/s/75.

Peace & Harmony

81: The Writings of Mother Teresa of Calcutta © by the Mother Teresa Center, exclusive licensee throughout the world of the Missionaries of Charity for the works of Mother Teresa. Used with permission.

82: Jimmy Carter, "Universal Declaration of Human Rights Remarks at a White House Meeting Commemorating the 30th Anniversary of the Declarations' Signing," The American Presidency Project, 6 December 1978.

Diversity

95: Kofi Annan quoted in ed. Shirley A. Jones, *Simply Living: The Spirit of the Indigenous People* (Novato, CA: New World Library, 1999), xx.

96: Winston Churchill, "Address on Post-War," 21 March 1943. http://www.cvce.eu/obj/address_given_by_winston_churchill_on_post

124

_war_21_march_1943-en-831b4069–27e5–4cd7 -a607–57d31278584d.html.

99: Billy Adler, *Ask Billy Graham: The World's Best Loved Preacher Answers Your Most Important Questions* (Nashville: Thomas Nelson, 2007), 222. Used with permission. www.thomasnelson .com.

100: Pope Francis, "Archbishop Kurtz Joins Pope Francis in Calling for Prayers, Action for Peace in Middle East, Ukraine, Africa, Central America," United States Conference of Catholic Bishops, 22 July 2014. Used with permission. http://www.usccb.org/news/2014/14–127.cfm.

103: Martin Luther King, Jr., *Strength to Love* (Minneapolis, MN: Fortress Press, 2010), 48.

© 1963 Dr. Martin Luther King Jr. Renewed 1991 Coretta Scott King. Reprinted by arrangement with The Heirs to the Estate of Martin Luther King Jr.,

104: John C. Fitzpatrick, *The Writings of George Washington*, Vol. 13: From the Original Manuscript Sources, 1745–1799 (London: Forgotten Books, 2017), 40. http://rotunda .upress.virginia.edu/founders/default. xqy?keys=FOEA-print-01–02–02–4429.

107: John Hume, "Nobel Lecture," Nobel Prizes and Laureates, 10 December 1998. https ://www.nobelprize.org/nobel_prizes/peace /laureates/1998/hume-lecture.html.

Triumph & Strength

112: George Bernard Shaw, *Everybody's Political What's What* (London: Constable and Company, 1944), 331.

115: Joseph P. Lash, *Helen and Teacher: The Story of Helen Keller and Anne Sullivan Macy* (New York: Delacorte Press, 1980), 487.

116: Barack Obama, "Super Tuesday Speech," Chicago, IL, 5 February 2008. http:// obamaspeeches.com/E02-Barack-Obama -Super-Tuesday-Chicago-IL-February-5–2008 .htm.

119: Ronald Reagan in a dedication speech of Reagan Library, also in Michael Reagan, Lessons My Father Taught Me: The Strength, Integrity, and Faith of Ronald Reagan (West Palm Beach, FL: Humanix Books, 2016), 202.

120: Mattie Stepanek, Mattie J.T. Stepanek Foundation. Used with permission. http://www .mattieonline.com/.

Quotation Copyright Information

Christina Baldwin: Excerpt from *Life's Companion: Journal Writing as a Spiritual Practice*, by Christina Baldwin, copyright © 1990 by Christian Baldwin. Used by permission of Bantam Books, an imprint of Random House, a division of Penguin Random House LLC. All rights reserved.

Albert Einstein: © The Hebrew University of Jerusalem

Tony Evans: Excerpted from *Kingdom Marriage*, by Tony Evans, a Focus on the Family book published by Tyndale House Publishers, Inc. © 2016 Tony Evans. Used with permission.

C. S. Lewis: *The Four Loves*, by C. S. Lewis copyright © C. S. Lewis Pte. Ltd. 1960. Extract reprinted by permission.

Martin Luther King Jr.: Reprinted by agreement with The Heirs to the Estate of Martin Luther King Jr., c/o Writers House as agent for the proprietor New York, NY. © 1963 Dr. Martin Luther King Jr. © renewed 1991 Coretta Scott King.

Henri Nouwen: Excerpt from *Compassion: A Reflection on the Christian Life*, by Donald P. McNeill, Douglas A. Morrison, and Henri J. M. Nouwen, copyright © 1982 by Donald P. McNeill, Douglas A. Morrison, and Henri J. M. Nouwen. Used by permission of Doubleday, an imprint of the Knopf Doubleday Publishing Group, a division of Penguin Random House LLC. All rights reserved.

Mother Teresa: The writings of Mother Teresa of Calcutta © by the Mother Teresa Center, exclusive licensee throughout the world of the Missionaries of Charity for the works of Mother Teresa. Used with permission.

About the Author

Warren Photographic combines the artistic talents of Jane Burton and Mark Taylor, a mother-and-son team based in Surrey, England. Their work has been published in books and magazines, on greeting cards and calendars, and on a wide range of stationery and giftware. Many of the animals featured in their photographs are born and raised at the studio and have been introduced to each other and to modeling at an early age, allowing them to feel relaxed in each other's company on the set.

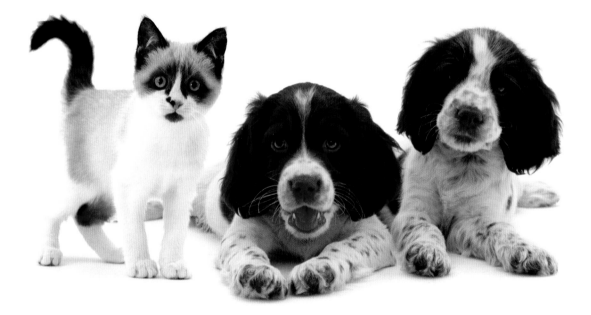